af

José Maria

y Martha

THE POCKET LIBRARY OF GREAT ART

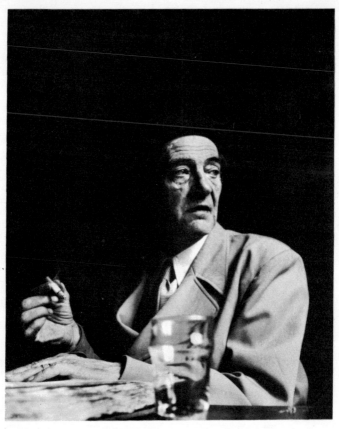

Plate 1. MAURICE UTRILLO. *Photograph by N. R. Farbman*
Courtesy Life Magazine

MAURICE

UTRILLO

(1883–)

text by

ALFRED WERNER

published by HARRY N. ABRAMS, INC., *in association*
with POCKET BOOKS, INC., *New York*

On the cover
detail of MONTMARTRE *(plate 27)*

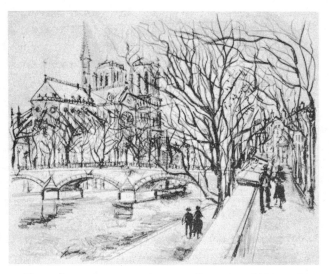

Plate 2. THE APSE OF NOTRE DAME. *About 1924. Lithograph*
Museum of Modern Art, New York

Maurice, Utrillo, V.

In the entire history of modern art, miracles have occurred only twice, and both times in France. Just before 1900, a poor, middle-aged civil servant, Henri Rousseau, a self-taught "Sunday painter," infused new energies and ideas into art. Shortly thereafter, a young, half-mad alcoholic of Montmartre, Maurice Utrillo, presented strange landscapes which delighted the man in the street and astonished the connoisseur.

These pictures inspired many artists to re-examine their world and, instead of turning to abstraction, once again to re-create reality. Yet, except for the miraculous element of self-preservation through art, no parallel exists between the two masters. Utrillo was the pupil of his outstanding mother, Suzanne Valadon, and a close friend of Amedeo Modigliani. Unlike Rousseau, Utrillo is not a primitive. He has been a professional painter all his life.

His is an incredible story. He might very well have ended his days, unknown to the world, as a patient in a sanatorium. Born in Paris in 1883, Utrillo is the offspring of a liaison between a teen-age model, Marie-Clémentine Valadon, and, so it is thought, a young amateur painter and chronic alcoholic, named Boissy. The boy's mother, an illegitimate child of peasant stock, later became the protégée of Toulouse-Lautrec, upon whose advice she changed her first name to the more elegant "Suzanne." It was Toulouse-Lautrec who introduced her to the great master Degas, who taught and encouraged her to paint.

Maurice Valadon was only a child when the Spanish writer and art critic, Miguel Utrillo, a friend of Suzanne's, in a spirit of kindness, bestowed upon him his own name. A highly neurotic youngster, Maurice was a poor student in secondary school. He was a failure, to say the least, as a bank clerk, and by the time he was eighteen had become an alcoholic and had to be temporarily committed to an asylum. It was "occupational therapy" which saved

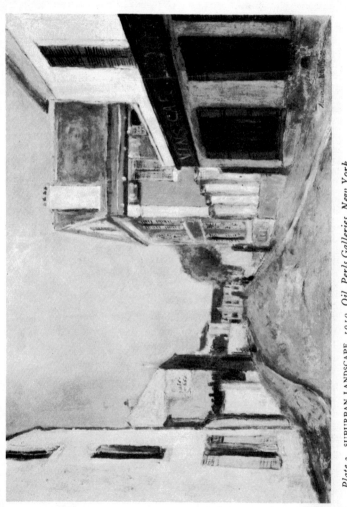

Plate 3. SUBURBAN LANDSCAPE. *1910. Oil. Perls Galleries, New York*

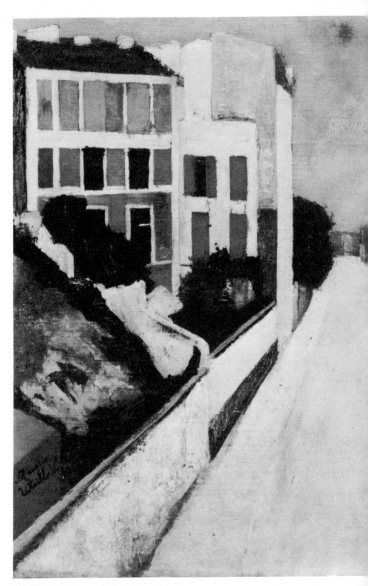

Plate 4. RUE DE CRIMÉE. *1910. Oil. Collection Mrs. Henry Church, New*

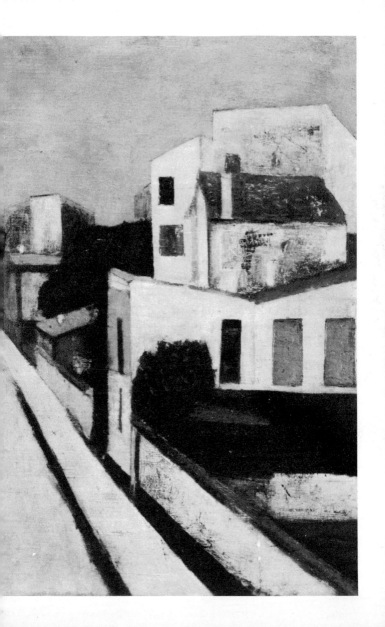

him and his hidden genius. Upon a physician's advice, Suzanne urged Maurice to take up painting as an emotional outlet through which he might regain his equilibrium. This experiment worked so well that in the past fifty years Maurice Utrillo has produced thousands of oils, gouaches, water colors, and pencil sketches, relying chiefly on his memory or the picture postcards in his possession. By 1920, he had become a legendary figure, internationally known. In 1929, the French Republic awarded him the Cross of the Legion of Honor, In his fifties he married an energetic widow, Lucie Pauwels, who managed his interests so ably that they could purchase a luxurious villa in the neighborhood of Paris where the couple is still living in grand style. It is known that, from his first confinement to an asylum to his retirement at Le Vésinet in the late thirties, Utrillo had many alcoholic relapses with self-destructive tendencies. He owes his redemption largely to the watchfulness of his mother, and then of his wife who became another gentle, but firm "jailer." Even today it cannot be said that Utrillo is "a mind that found itself."

Of greater importance than his case history is the genius that alcohol was not able to destroy. Many artists and critics regard him as the greatest landscape painter of this century. But, in spite of his admittedly high standing, one is painfully aware of his total lack of self-criticism which permits the creation of both unbelievably inferior works and of indisputable masterpieces. Nor can one overlook the

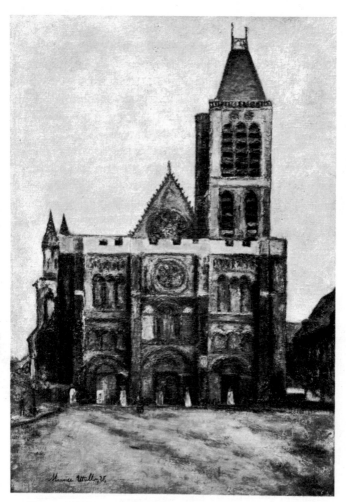

Plate 5. ABBEY OF SAINT-DENIS. *1910. Oil*
The Phillips Collection, Washington, D. C.

absence of intellectual concepts and the endless repetition of the same motifs in the same manner. Still, if Utrillo is only an eye, as Cézanne said about Monet, one can continue with Cézanne: "But what an eye!"

Above all, Utrillo has an eye for Montmartre—the old, picturesque, and relatively quiet artists' quarter as it existed before the First World War. He is fascinated by the sad little streets and miserable bistros of the industrial suburbs. It is true that he also painted some of the great cathedrals of France and panoramas of Brittany and Corsica, as well as a few flower pieces, but it is as the painter of the unheralded sights of the French capital that he will be known forever.

One may recognize the influence of Pissarro and Cézanne, but his solidity of composition, his gift for simplification, and his unerring sense of color relation are instinctive to him. Just as he is not a primitive, neither is he a classicist, a realist, an Impressionist, a Fauve, an Expressionist, nor even a Romantic. He is a complete individualist who defies all classifications. It is customary to concentrate on the pictures of his "white period," when roughly between 1909 and 1914, white tints and shades were prominent in his work. However, the years preceding those of his "white period" yielded many fine paintings; and in the paintings of his later "colorist period" he often used bright and gay hues successfully.

Utrillo is one of the few contemporary painters whose works please sophisticated as well as simple

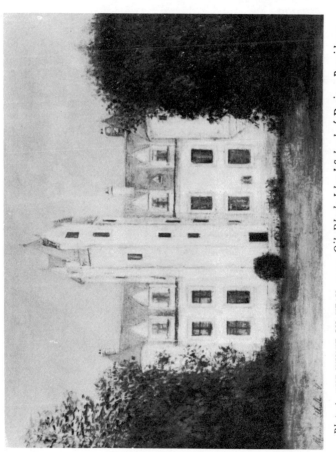

Plate 6. THE WHITE CHATEAU. *1911. Oil. Rhode Island School of Design, Providence*

tastes. Despite changing fashions and the fluctuations of the market, his canvases bring higher and higher prices with each year—good Utrillos of the "white period" are sold for thousands of dollars. Now universally respected, he has been challenged in the courts twice and emerged victorious each time: once when American customs officials had denounced his work as dutiable products because they had been done with the aid of picture postcards; and another time when a catalogue of a London museum stated that the artist had long since perished, a victim of excessive drinking. In the second case, the squire of Le Vésinet was able to convince a British court that he was very much alive, and was dividing his time between work and religious devotion.

Now seventy, Utrillo still remembers and paints the Bohemian and proletarian Paris which he roamed as a frustrated, unhappy young ruffian, yet he never visits these scenes. His life will have no tragic ending à la Van Gogh, Modigliani, or Pascin. The story's end is peace—the same peace that greets the beholder of Utrillo's transfigurations of even the most sordid places; the peace that as an old man he is now seeking with the believing soul of a child.

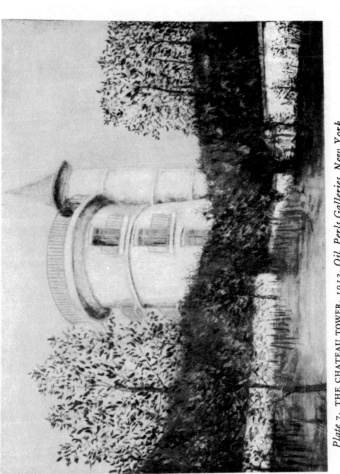

Plate 7. THE CHATEAU TOWER. *1912. Oil. Perls Galleries, New York*

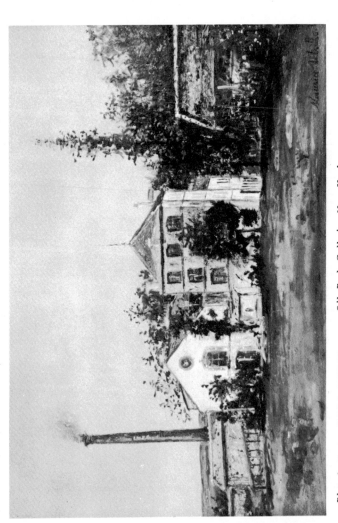

Plate 8. HAT FACTORY, GONESSE. *1914. Oil. Perls Galleries, New York*

COLOR PLATES

PLATE 9

Painted about 1909

RUE DE LA JONQUIERE

Collection Alex L. Hillman, New York

23 x 31"

The year 1909, when this oil was painted, was an important one in Utrillo's life. After six years of industrious work he had achieved his own, unmistakable style. Critics and dealers usually date the beginning of his "white period" from this year.

Painted on cardboard, as were many of Utrillo's earlier works, this scene from a window under the eaves is reminiscent of the *perspective plongeante*— the sharp downward view—favored by Pissarro more than a decade earlier. But while Pissarro chose for his motifs the Avenue de l'Opéra or the Boulevard des Italiens, broad and gay with throngs of people, trees, and vehicles, the shy and moody Utrillo selected the narrow, sparsely-peopled streets of the lower classes.

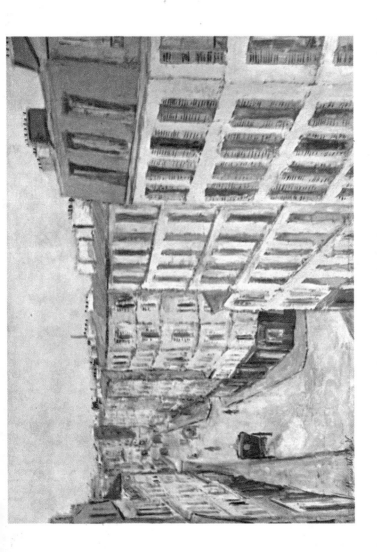

PLATE 10

Painted 1909–10

RENOIR'S GARDEN

Collection Gregoire Tarnapol, New York
21½ x 31¾"

For several years the great Impressionist painter, Auguste Renoir, lived with his family in the Château des Brouillards ("Castle of Mists"), the large house at the right of the picture. The whole section, which in Renoir's time was semi-rural, has now been completely built up. Renoir's house is now owned by the musician Marius Casadesus.

A striking feature of this painting is the dream-like vision of the church of Sacré-Coeur, silhouetted against the grayish-blue sky. However much the gaudy Romanesque-Byzantine structure may lose on close inspection, seen from a distance it is most impressive as a floating white mass of granite and marble perched on the hill of Montmartre. Thus Utrillo sees it in this painting of about 1910.

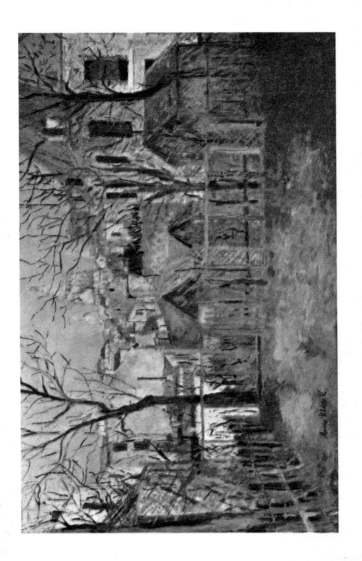

PLATE 11

Painted about 1910

BISTROS IN A SUBURB

Collection Mr. and Mrs. Peter A. Rubel, New York

$21\frac{1}{4} \times 25\frac{5}{8}''$

"Bistro" is an internationally used slang word meaning "pub" or "saloon." The suburb in this instance is probably the drab and uninspiring town of Sannois just north of Paris. No tourist seeks it out, and neither Monet nor Pissarro would have wasted his brush on it. But Utrillo, then an outcast, friendless and socially inhibited, often roamed in it and in other such workers' districts and painted sunless scenes of poverty and neglect. Among dealers, the term *Utrillo de bistro* was coined especially for little pictures such as this one, painted in cafés or inns in return for a bottle of cheap wine.

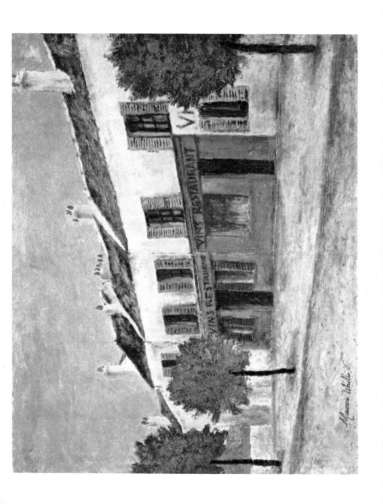

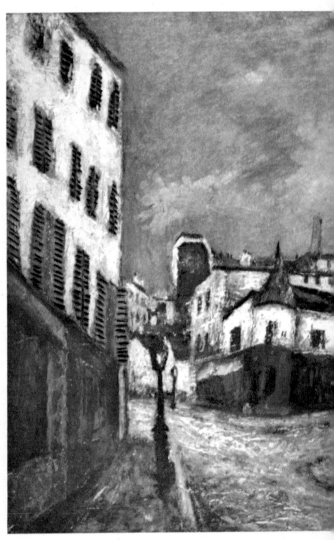

Plate 12. A LA TOURELLE ET RUE DU MONT CENIS *(commentary fo*

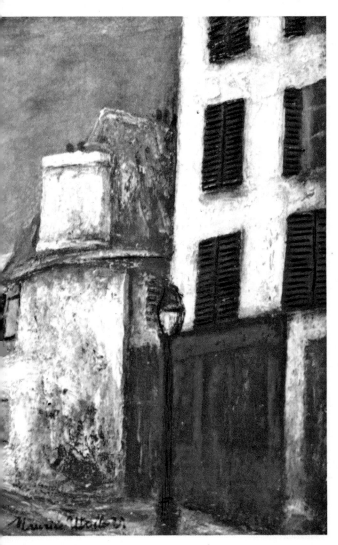

(or plate section)

Painted about 1910

THE CHURCH OF LA FERTE-MILON

Collection Dalzell Hatfield, Los Angeles
42 x 32"

La Ferté-Milon is a village northeast of Paris, not far from the Château-Thierry of World War I fame. Utrillo's predilection for out-of-the-way and "uninteresting" places such as this is perhaps an unconscious revenge on the tourists, whose noisy behavior the shy and misanthropic artist dreads. Though a citydweller at heart, he feels comfortable in "La France qui travaille," the ageless rural France where people are slow and pious and as deeply rooted in the good earth as this simple medieval church.

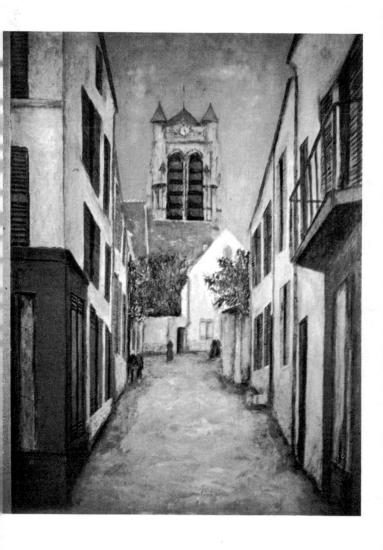

PLATE 14

Painted about 1911

FACTORIES (LES FABRIQUES)

Lewyt Collection, New York

19½ x 28¾"

Here we have a study in color and form relations with an unorthodox use of perspective unusual with Utrillo. Like the Fauves and the Cubists, but without program, Utrillo reduces houses, chimneys, and windows to geometrical statements, to arrangements of horizontal and vertical lines, filling in the forms with color.

That a tree could grow in such a bleak and dreary neighborhood as this is ironic, and one grasps the irony of the gay red and yellow on the dismal factory walls. Under the unbelievably pleasant and traditional sky, the absence of human beings is even more haunting than in *Rue Ravignan* (plate 15).

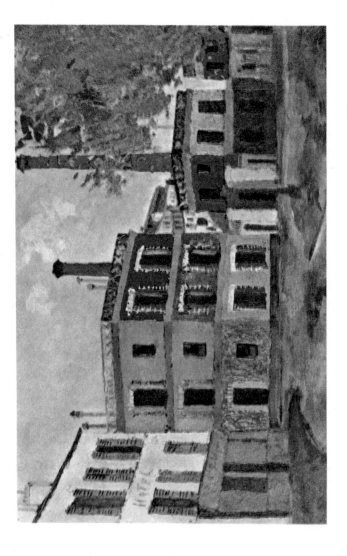

PLATE 15

Painted about 1911

RUE RAVIGNAN

Collection Gregoire Tarnapol, New York
23¾ x 28¾"

From the top of Rue Ravignan one can see Paris
stretching southward as far as the Meudon hills. But
Utrillo, painter of houses rather than of landscape
panoramas, chose to focus upon three or four pieces
of banal architecture and to invest them with a strange
life of their own. The appeal in this picture depends
mainly on composition and color—the well-balanced
relationship of hues and geometrical forms. White
and blue-black, as in most works done in the "white
period," play the dominant role. Not satisfied with
zinc white from the tube, Utrillo mixed it with plaster
and applied it thickly with the palette knife, almost
the way a mason covers bricks with plaster.

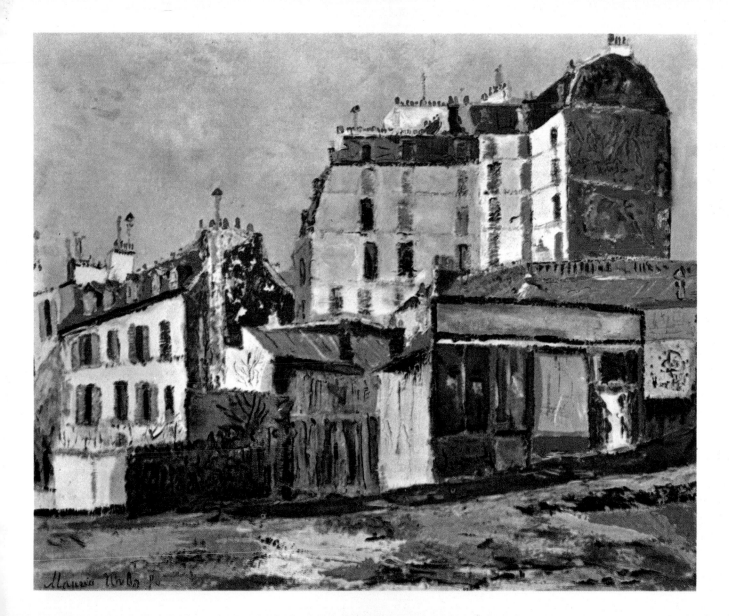

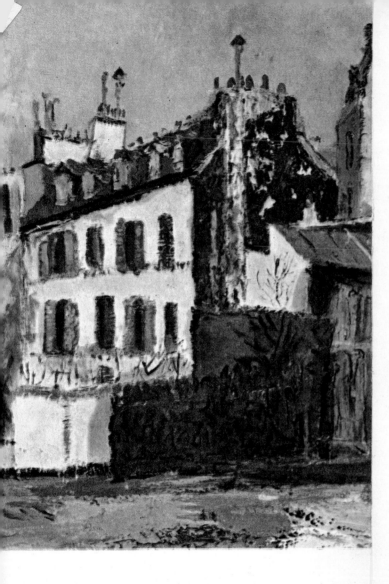

PLATE 16

Painted about 1911–12

PLACE DU TERTRE

Tate Gallery, London

19⅞ x 28¾"

This picture shows the square in the heart of Montmartre—originally the main square of what had been an independent village outside of Paris—in late fall or winter. Utrillo's melancholy nature preferred the desolate seasons of late autumn and winter with their low-keyed colors and the vein-like patterns of leafless trees. Here, as in many other pictures, Utrillo is fascinated by the lettering on stores and buildings. These letters—over-large and stiff—are introduced for their decorative effect as well as for what they suggest.

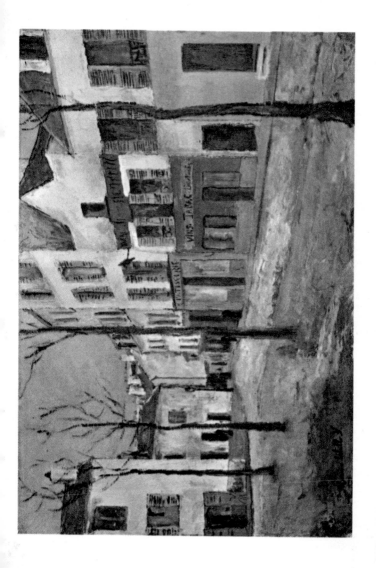

PLATE 17

Painted about 1913

PLACE DU TERTRE

Collection Mr. and Mrs. John Hay Whitney, New York

23 x 31"

A different view of the main square of La Butte Montmartre, with the Hotel du Tertre to the left. The round tower ("Colonne Morris") in the center, carrying theater and cabaret advertisements, is the Parisian equivalent of a billboard. The painting is significant for its simplification of drawing which reduces houses, windows, and doors to an almost impersonal geometric statement. Here, as in many of his pictures of Montmartre, the flat planes in the foreground are balanced by the hemisphere of the Sacré-Coeur cupola in the background, a contrast of shapes which always fascinates Utrillo.

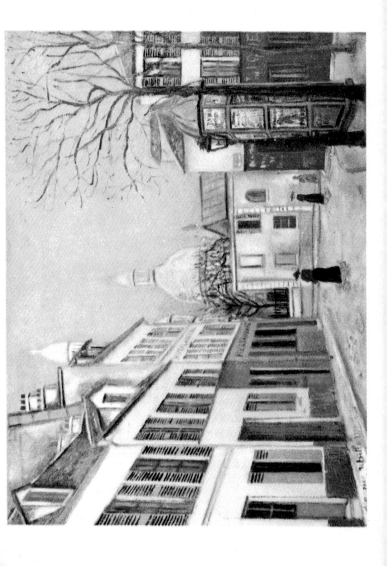

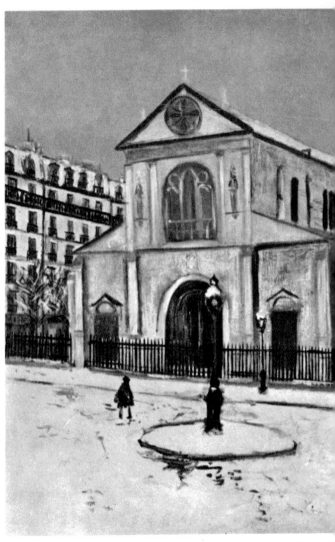

Plate 18. NOTRE-DAME DE CLIGNANCOURT *(commentary follows co*

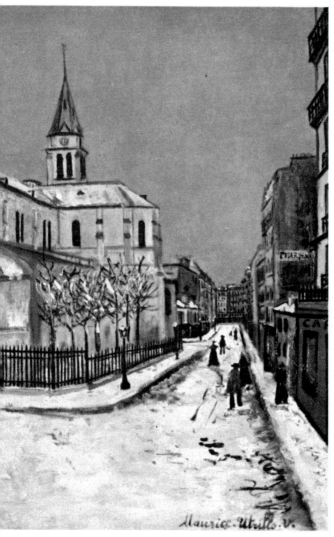

section)

PLATE 19

Painted about 1913

CHARTRES CATHEDRAL

Collection Mrs. L. B. Wescott, Clinton, N. J.

35¾ x 19½"

A devout Catholic, Utrillo has painted dozens of French churches ranging from the great cathedrals to the small churches of the countryside. Viewing the Gothic edifice of Chartres in a spirit of profound humility, he worked with a patience and meticulousness reminiscent of the old masters. His painting of Chartres conveys a sense of stability and durability for which one will look in vain in the Impressionists' paintings of churches. This imposing canvas was produced when Utrillo was thirty years old and at the height of his "white period."

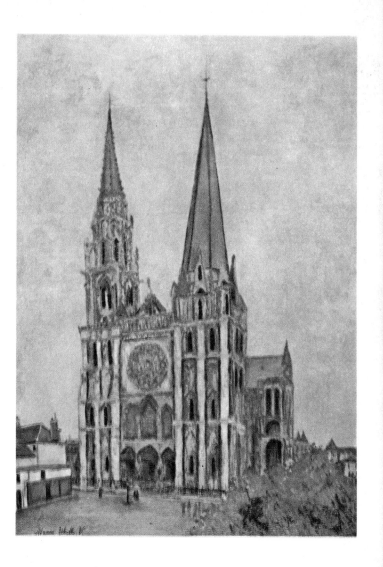

PLATE 20

Painted about 1912

RUE CHAPPE

Private Collection, New York

21 x 29"

Rue Chappe leads northward to the top of La Butte Montmartre, the last stretch of it being a flight of stairs. This picture, like *Rue de la Jonquière* (plate 9), was painted from a high window. Exciting effects are created by the rich texture, and the picture sparkles like the best Impressionist paintings, yet it is not restricted to capturing the fleeting effects of light.

LIFT FOLD FOR ENTIRE PAINTING →

DETAIL AT RIGHT

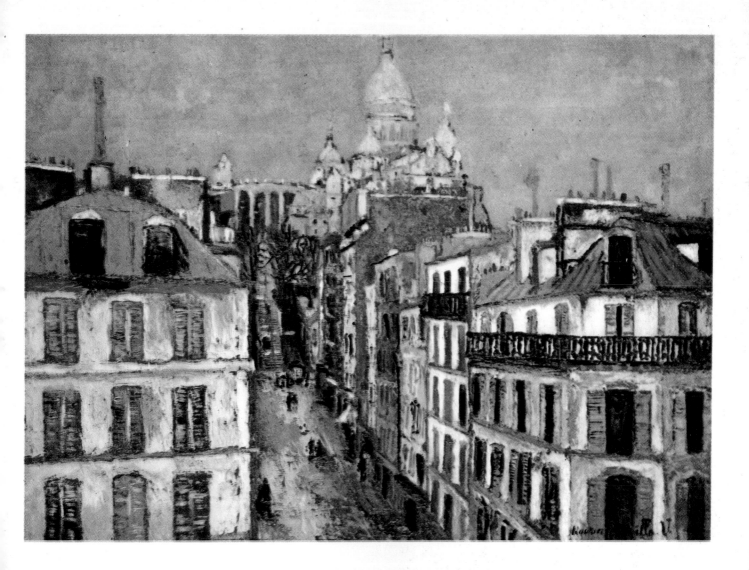

PLATE 21

Painted 1914

PLACE DU TERTRE,
THE FOURTEENTH OF JULY

Collection Alfred Schwabacher, New York

18 x 23¼"

This is one of the gayer and more colorful of the
artist's early pictures and anticipates his later "colorist
period." There is great delight in working out the
pattern of scrubby foliage, into which are woven the
bright flags of the French Republic commemorating
Bastille Day. In the background is the Hôtel du Tertre
which Utrillo painted many times. The dearth of
human activity and the slightly derelict air of the
little square contrast with the brave, colored bunting,
striking the familiar Utrillo note of melancholy mixed
with tenderness.

PLATE 22

Painted about 1920

A COUNTRY CHURCH

Museum of Modern Art, New York

25½ x 19½"

There are scores of little Romanesque and Gothic churches like this in France. Sturdy, defiant, and for-tress-like, they sheltered the villagers during the Middle Ages when the country was torn by wars and civil strife. As a composition, this canvas is reminiscent of Corot, for here, as in the early work of the nine-teenth-century master, every stone has its pictorial and plastic value. Nothing seems able to disturb the archi-tectural order of this aged mass of solid masonry.

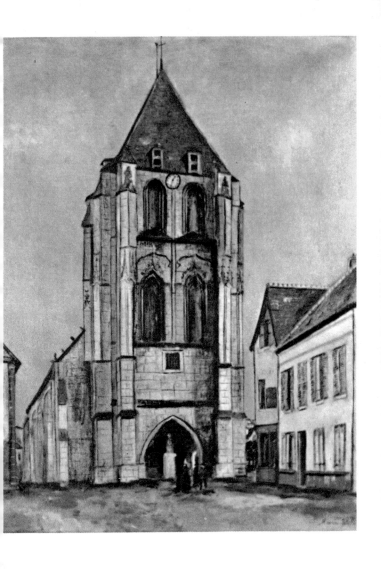

PLATE 2 3

Painted in 1923

STREET IN ORTHEZ

Perls Galleries, New York
15⅛ x 18⅛"

Stopping on a trip in this picturesque and little-known village in the lower Pyrenees, Utrillo returned to his earlier practice of painting directly from the scene rather than from memory or picture postcards. It is a particularly well-integrated work. The sky and foliage are full of dramatic accents, not, as Utrillo often painted them, simplified so as to appear monochromatic and flat. The colors are hot and high-keyed with red predominating, and the cool blues have an admixture of red which lends them a warm, purple cast. The southern gaiety and sunniness of the locale seem to have inspired the vivid coloring of the picture, a marked change from the subdued key of the oils Utrillo painted in northern France.

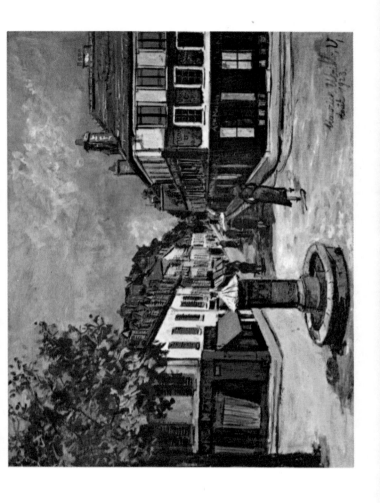

PLATE 24

Painted about 1917

THE BERLIOZ HOUSE
AND THE HUNTING LODGE OF HENRY IV

The Art Gallery of Toronto, Canada

$21\frac{1}{4}$ x $28\frac{3}{4}$"

The modest little house in the lower left corner was inhabited between 1834 and 1837 by the composer Hector Berlioz and his English-born wife in the first years of their romantic marriage. Tradition has it that somewhere in this neighborhood stood a hunting lodge owned by the sixteenth-century French king, Henry IV. After World War I both houses were razed, and the district of Montmartre was covered with large, modern residences. Whatever the importance of this picture may be as a historical document, we regard it as a calm and muted symphony, linking together the leaden sky, the white walls, the red roofs, and the intertwining boughs of winter trees.

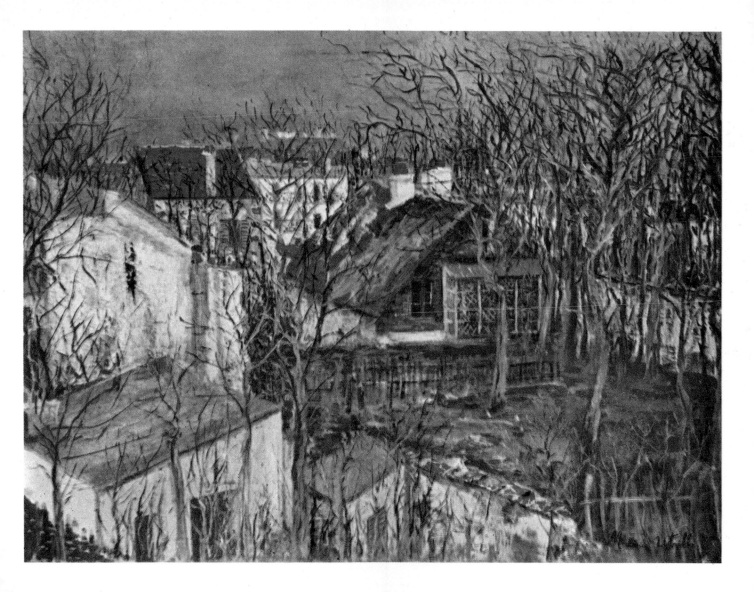

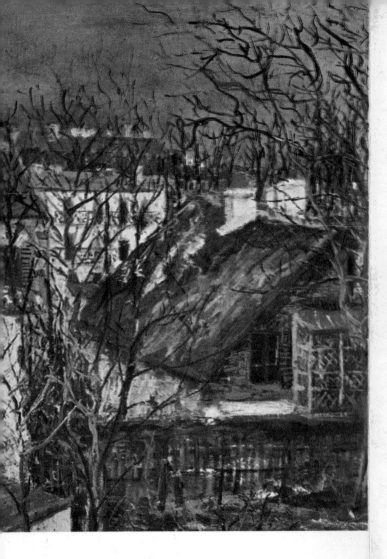

PLATE 25

Painted about 1930

LAPIN AGILE

Fine Arts Associates, New York

18 x 22"

The Lapin Agile was one of the celebrated cabarets of Montmartre. Its name, which can be translated as "agile rabbit," is a pun on the name of the caricaturist André Gill, who once used the building as a studio and for some reason painted a large white rabbit above the door. The cabaret was patronized by such painters as Picasso, Modigliani, Braque, Dufy, and Utrillo, who decorated the walls with their work. It was a place full of memories for Utrillo, and he painted it many times. The present picture has great charm of color, although it may lack some of the formal discipline that marks his earlier versions.

◄— LIFT FOLD FOR ENTIRE PAINTING

DETAIL ABOVE

LIFT FOLD FOR ENTIRE PAINTING —►

DETAIL AT RIGHT

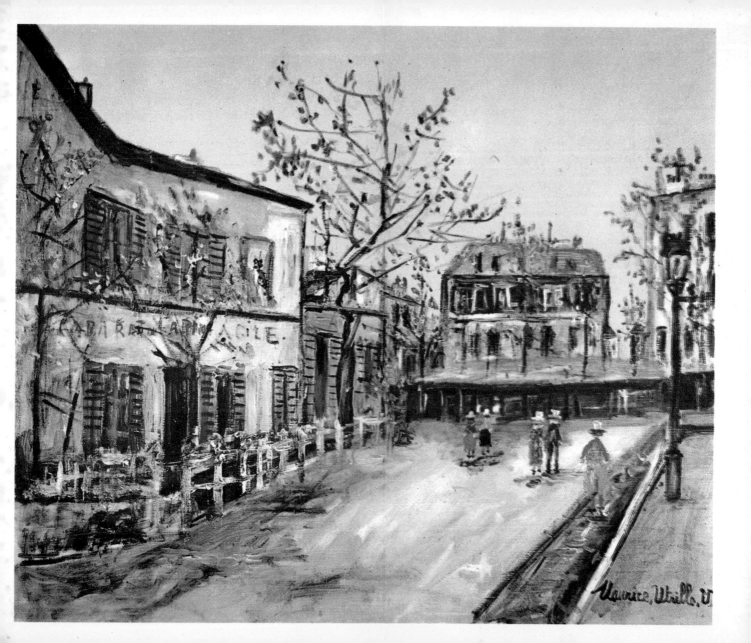

PLATE 26

Painted in 1934

SACRE-COEUR DE MONTMARTRE
AND PASSAGE COTTIN

Collection William P. Seligman, New York
24⅞ x 18¾"

Painted in gouache—opaque water color prepared with gum—this picture is a product of Utrillo's "colorist period." Here the dominant color is white only because the scene represents winter. Generally, the pictures painted after 1920 abound in gay and bright colors which are rare among the Utrillos of the "white period." Everything is daintier and more meticulously drawn, but the over-all effect is weaker. Typical of his work at this time are the people who are no longer mere specks of color. One notices how often the figures in Utrillo's paintings are moving away from the spectator, suggesting an effect of loneliness and isolation.

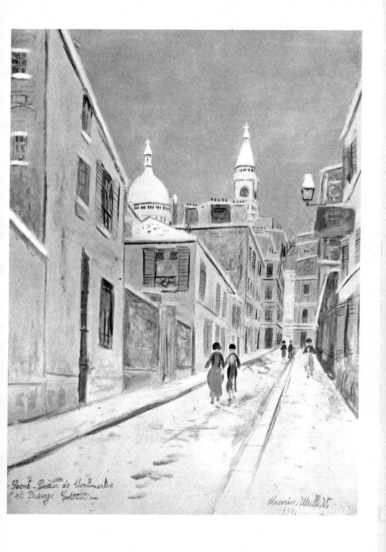

Sacré-Cœur de Montmartre
et Passage Cottin —

Maurice Utrillo V.
1934.

PLATE 2 7

Painted about 1938

MONTMARTRE

Schoneman Galleries, New York

15 x 18"

In the thirties Utrillo's style suddenly relaxed; he loosened his design and began to apply bright dabs of pigment with an almost child-like relish. The result was a new simplicity and charm. Here, it is as if the forlorn, somber facades that he dwelt on in early versions of Montmartre had been given a fresh coat of paint. The sparkling colors are in violent contrast to the austere palette of his "white period."

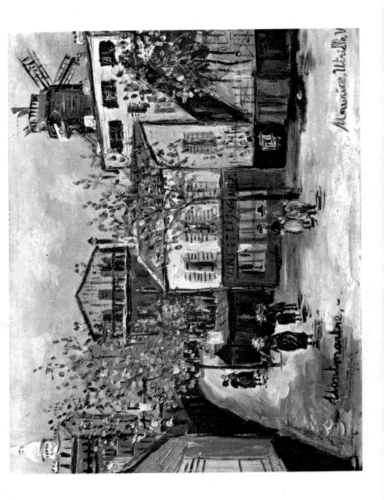

Maurice Utrillo, V

Montmartre.

PLATE 28

Painted in 1946

FLOWER STILL LIFE

Collection Miss Lily Pons, New York

36 x 28"

Undoubtedly, the shy Utrillo prefers flowers to people. They do not upset him by endless talk, they can be taken up, arranged, and discarded at will. Unlike the Impressionists before him, he does not care to wrap his flowers in a glowing, vibrating light. From Cézanne—who even used artificial flowers as models— Utrillo learned how to rescue painted flowers from the atmospheric mists in which they sometimes became lost. With vehement, expressive brush strokes, Utrillo gives these calla lilies and hothouse carnations something of the melancholy overtones and artificiality of his street scenes.

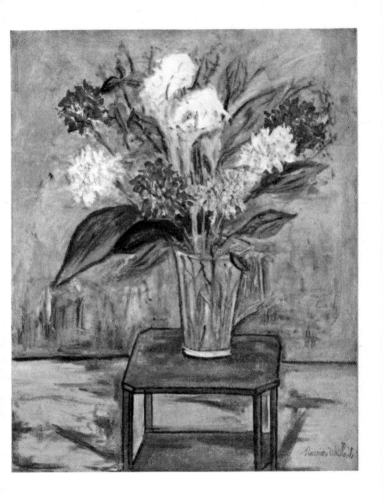

Painted about 1910

A LA TOURELLE ET RUE DU MONT CENIS

Collection Dr. and Mrs. John J. Mayers, New York
17¾ x 24"

The Rue du Mont Cénis extends from the Boulevard Ney, in the north of Paris, straight to the Place du Tertre, the heart of Montmartre. The corner build-ing in the center, with its small, pointed tower ("tourelle"), houses a well-known restaurant, *A la Tourelle*. Yet the Paris that Utrillo has painted here is not the gay city of the tourist, nor the ethereal and youthful city that we know from Dufy's light and fragrant sketches. Here Paris has the wrinkled face of an old woman. In this apparently undramatic and un-peopled world the gas lights seem to take the place of pedestrians.

Painted about 1912

NOTRE-DAME DE CLIGNANCOURT

Collection Mrs. Camille Dreyfus, New York

24 x 32"

Utrillo painted this nineteenth-century Paris church many times and from many angles. In this version, the streets are covered with snow and the spectator is standing in the Place Jules Joffrin looking northward toward the suburbs, with the Rue Hermel to his right, and the Rue du Mont Cénis to his left. Here the artist has once again proved his ability to "clothe in splendor all that the casual eye of the passerby neglects," as Adolphe Tabarant has said. It is a curious fact that Utrillo, even at the time when he was called an alcoholic, never allowed doubt or disorder to mar the strict construction and clarity of statement of his paintings.

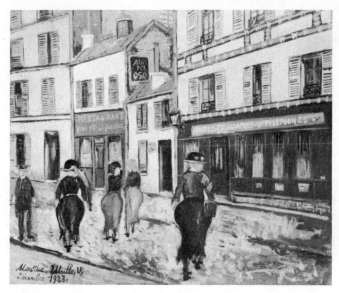

Plate 29. STREET SCENE. *1923. Oil. Knoedler Galleries, N. Y.*

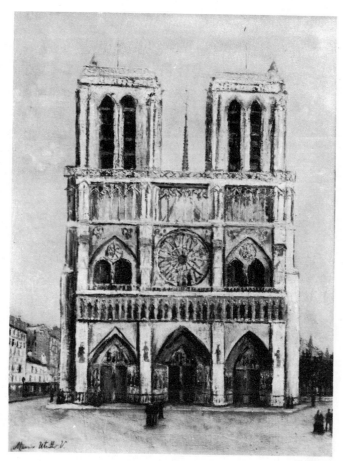

Plate 30. NOTRE DAME DE PARIS. *1914-15. Oil. Knoedler Galleries, N. Y.*

Plate 31. COMPIEGNE BARRACKS. *1915. Oil. Perls Galleries, New York*

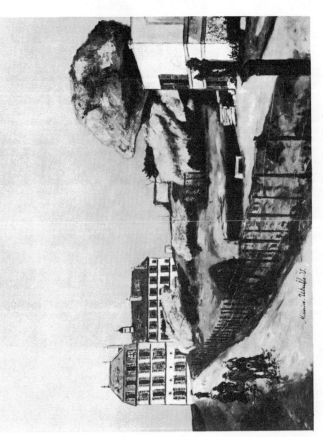

Plate 32. COTE DU NORD. *1917. Oil. Niveau Gallery, New York*

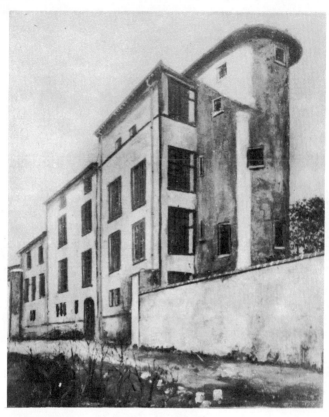

Plate 33. FACTORY STREET. *1916-17. Oil*
Collection Jon Nicholas Streep, New York

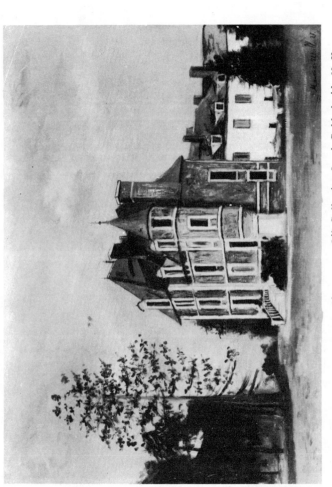

Plate 34. CHATEAU DE LA SALLE. *About 1919. Oil. Collection Jacob Goldschmidt, N. Y.*

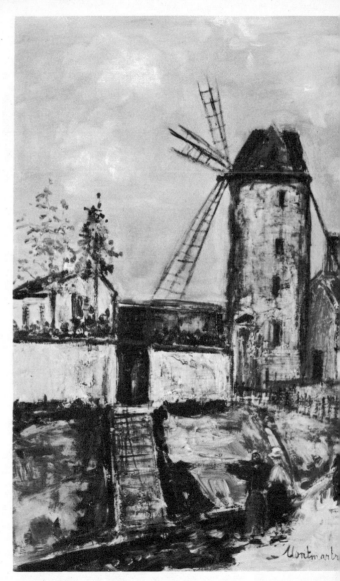

Plate 35. WINDMILLS OF MONTMARTRE. *1949. Oil. Collection Dr.*

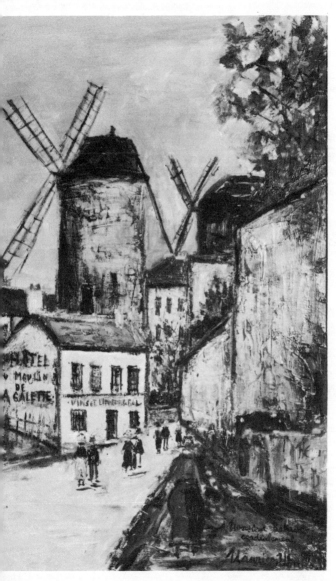

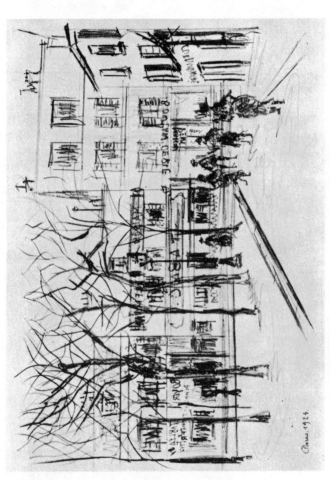

Plate 36. PLACE DU TERTRE. *About 1924. Lithograph. Museum of Modern Art, N. Y.*

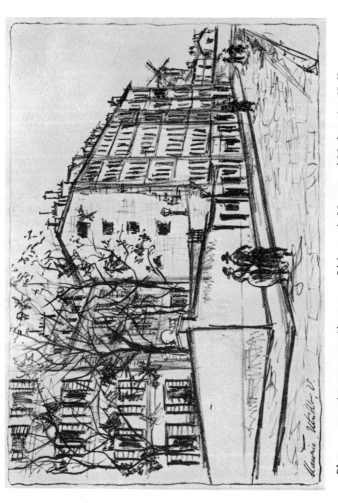

Plate 37. RUE D'ORCHAMPT. *About 1924. Lithograph. Museum of Modern Art, N. Y.*

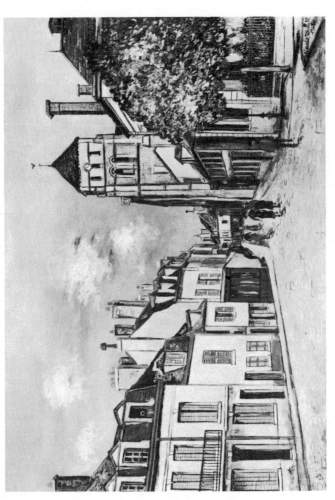

Plate 38. RUE ST. JACQUES A COSNE. 1925. Oil. Niveau Gallery, New York

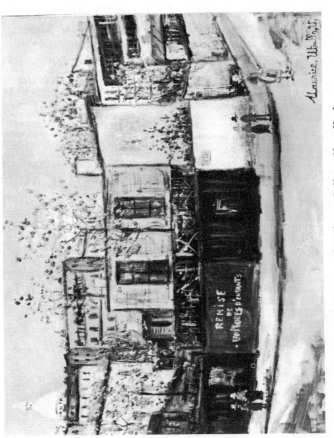

Plate 39. RUE LAMARCK. 1942. Oil. Niveau Gallery, New York

BIOGRAPHICAL NOTES

1883 Maurice Utrillo (pronounced *oo-TREE-oh*) born December 26, Paris. Illegitimate son of Marie-Clémentine Valadon, who later paints under the name of Suzanne Valadon.

1891 Legally adopted by Spanish journalist, Miguel Utrillo.

1901 First of alcoholic "cures" in a sanatorium. Suzanne persuades him to paint as therapy.

1910 Critics Francis Jourdain and Elie Faure "discover" Utrillo's paintings in an obscure gallery, hail him as a master.

1919 First public recognition of "white period" work (1909-14) in numerous exhibitions and favorable critical notices.

1923 Important show at Bernheim-Jeune with Valadon; gallery contract guarantees them joint annual income of 1,000,000 francs (about $40,000).

1924 Attempts suicide. Restored to health and sanity by mother at chateau near Lyon.

1929 Receives Cross of the Legion of Honor.

1935 Marries widow Lucie Pauwels and moves to Le Vésinet, fashionable Paris suburb.

1938 Suzanne Valadon dies.

1948 Utrillo given retrospective exhibition at the Salon d'Automne.

"Ah, Montmartre, with its provincial corners and its Bohemian ways, how many stories could be written on this section of Paris . . . I would be so at ease near you, sitting in my room, composing a motif of white-washed houses." Thus wrote Utrillo nostalgically in 1916, from an asylum, of that Paris quarter which was the inspiration and subject of most of his paintings.

For nearly fifty years Montmartre (the "holy hill") was the hub of the artistic universe. In the seventies, the Impressionists painted it and held forth in its cafés, turning them into casual forums of ideas. Later, Toulouse-Lautrec explored the flamboyant and licentious aspects of its cabaret life. In Utrillo's day, the Bohemian element dominated the locale, and such figures as Modigliani, Soutine, and Pascin divided honors with him for their carousing and unconventional living.

Despite Utrillo's participation in the contemporary café life of Montmartre at a time when its reputation as a raffish, Bohemian playground was flourishing, his paintings always expressed a nostalgia for the past. The Montmartre he saw and painted was the sleepy, medieval village rich in venerable landmarks: the churches on the Butte; the defunct windmills that once ground grain for the religionists of the "holy hill"; and streets like Rue des Abbesses whose names date back to the time when Montmartre was a concentration of abbeys and monasteries.

In 1912 an emigration led by Picasso shifted the center of Parisian artistic life back to the Latin Quarter. Utrillo stayed behind and went on painting his beloved quarter in an unbroken string of street scenes. His record of Montmartre's picturesque, crumbling beauty is a fitting epitaph for one of the richest legends of modern art.

SOME OTHER BOOKS
ABOUT UTRILLO

Francis Carco. *La Légende et la Vie d'Utrillo*. Paris, Grasset, 1928

Robert Coughlan. *The Wine of Genius*. New York, Harper, 1951 (Popular, illustrated biography)

George Slocombe. *Rebels in Art*. New York, Arts and Decoration Book Society, 1939

Adolphe Tabarant. *Maurice Utrillo*. Paris, Bernheim-Jeune, 1926

ACKNOWLEDGMENTS

In a book of art, it seems particularly fitting to acknowledge the work of craftsmen who contribute to its making. The color plates were made by Litho-Art, Inc., New York. The lithography is from the presses of The Meehan-Tooker Co., Inc., New York and the binding has been done by F. M. Charlton Co., New York. The paper was made by P. H. Glatfelter Co., Spring Grove, Pa. Our deepest indebtedness is to the museums, galleries, and private collectors who graciously permitted the reproduction of their paintings, drawings, and sculpture.